STARS WERE Gleaming

STARS WERE *Gleaming*

FEATURING THE ART OF

GREG OLSEN

DESERET BOOK

SALT LAKE CITY, UTAH

Art direction by Richard Erickson. Cover and interior design by Sheryl Dickert Smith. Production design by Kayla Hackett and Heather Ward.

Cover painting © 2014 Greg Olsen
Illustrations © 2014 Greg Olsen

Text © Deseret Book Company

Visit us at DeseretBook.com

Library of Congress Cataloging-in-Publication Data
(CIP on file)
ISBN 978-1-60907-941-3

Printed in China
R. R. Donnelley, Shenzhen, China

10 9 8 7 6 5 4 3 2 1

To:

Mom

From:

CURTIS & PAM "2014"

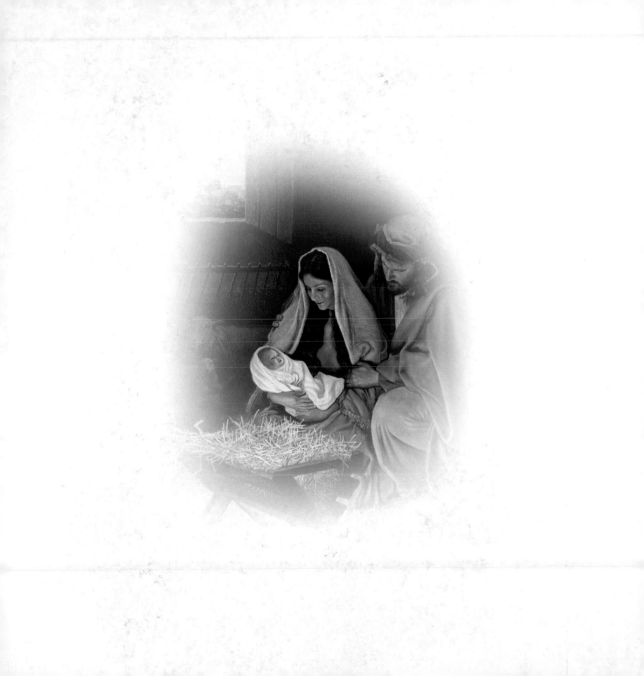

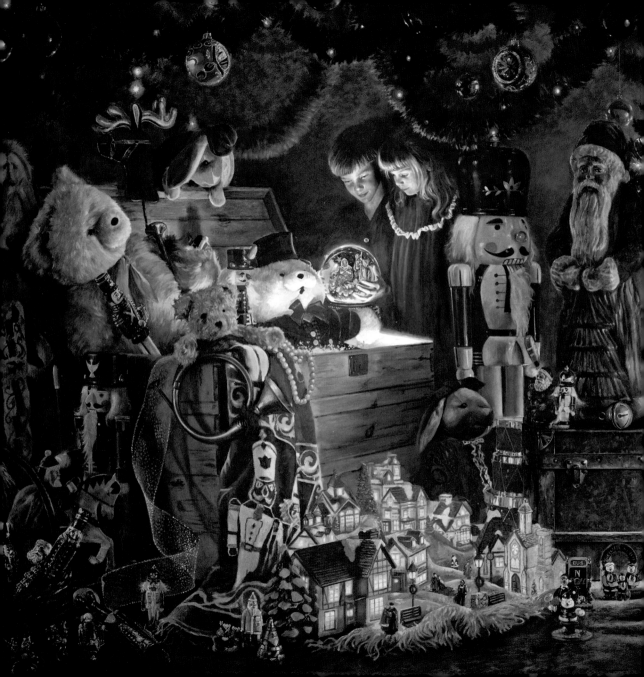

THE REASON FOR THE SEASON

*Christmas is such a wonderful time. No doubt it is
all Christendom's favorite season. Child and adult
alike look forward to this time, a time when our best
self shines through. What makes it so special? Certainly
it is our love for family and friends. But at the heart of
it all is remembering the birth of the Savior.*

—JAMES E. FAUST

At Christmas we celebrate the birth of the Savior,
but the real story of Christmas includes also his life, death,
and resurrection. He was born to give his life for us, to give
us immortality and the opportunity for eternal life. As we
think about and teach our families about Christmas, let us
teach them the full story—from Bethlehem to Calvary and
the Garden Tomb. Let us help them form their Christmas
traditions, centered on Christ and filled with gratitude for
what he did for us and we can do for him in return.

—ALBERT CHOULES, JR.

We all enjoy giving and receiving presents. But there is a difference between presents and gifts. The true gifts may be part of ourselves—giving of the riches of the heart and mind— and therefore more enduring and of far greater worth than presents bought at the store.

—JAMES E. FAUST

TRUE GIFTS

Christmas is a time for giving. Someone once said he couldn't think of what to give for Christmas. The next day in the mail he received an anonymous list which read:

GIVE TO YOUR ENEMY FORGIVENESS,

TO YOUR OPPONENT TOLERANCE,

TO YOUR FRIEND YOUR HEART,

TO ALL MEN CHARITY, FOR THE HANDS THAT

HELP ARE HOLIER THAN LIPS THAT PRAY,

TO EVERY CHILD A GOOD EXAMPLE, AND

TO YOURSELF—RESPECT.

All of us need to follow the example of the Savior in giving these kinds of gifts.

—HOWARD W. HUNTER

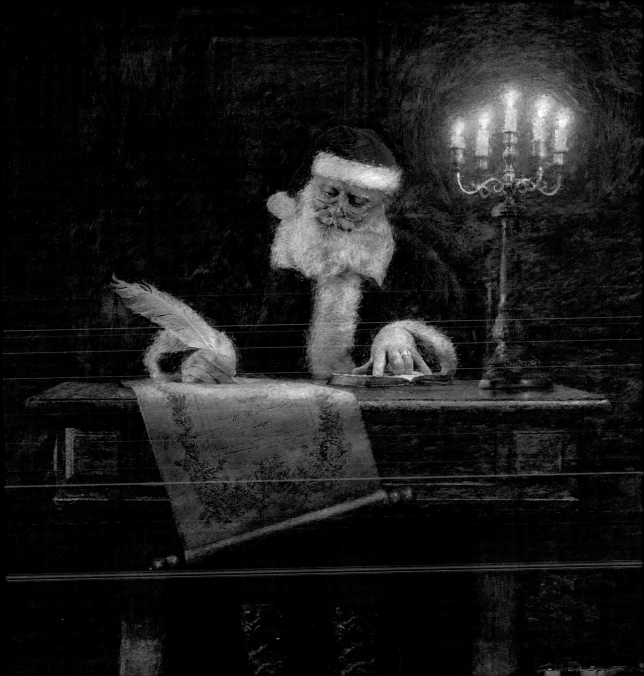

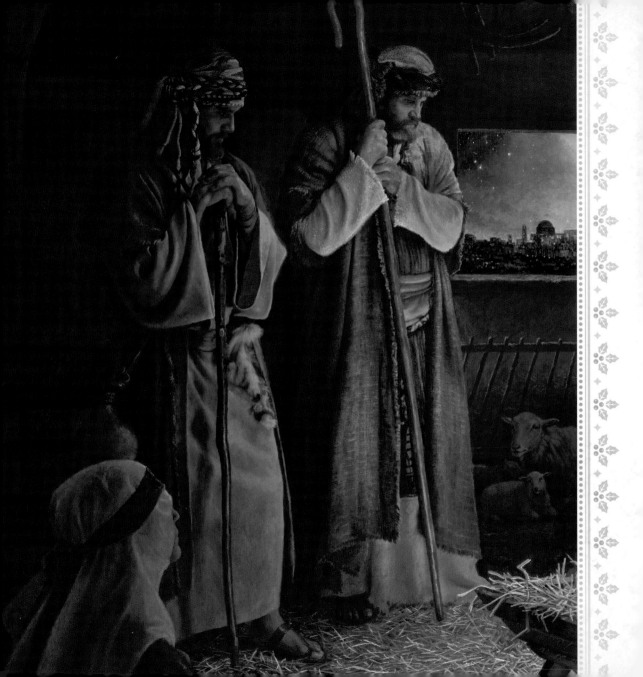

Faithful Shepherds

And they came with haste, and found Mary, and Joseph, and the babe lying in a manger. And when they had seen it, they made known abroad the saying which was told them concerning this child. And all they that heard it wondered at those things which were told them by the shepherds. But Mary kept all these things, and pondered them in her heart. And the shepherds returned, glorifying and praising God for all the things that they had heard and seen, as it was told unto them.

—Luke 2:16–20

We too must return to our fields and our homes and our offices and our meetings, glorifying and praising. We need to work, but we must do it with a renewed focus and purpose. Sheep need tending now as they did then. Faithful shepherds will always be found at their posts, with Jesus at the center of their lives and hearts because they know and love him.

—Jay E. Jensen

For God so loved
the world, that
he gave his only
begotten Son, that
whosoever believeth
in him should not
perish, but have
everlasting life. For
God sent not his
Son into the world
to condemn the
world; but that the
world through him
might be saved.

—John 3:16–17

O HOLY CHILD

O holy Child of Bethlehem!
Descend to us, we pray;
Cast out our sin, and enter in,
Be born in us today.

—Phillips Brooks

Today Jesus stands at the citadel of our souls pleading for entrance. He pleads through the spoken word. He pleads through the scriptures. He pleads through the voice of the Spirit. He pleads through the voice of reason. He pleads through the witness of faithful parents and friends. But because we have no space left, we reply, "No room, no room." We have no room for Jesus because most of us are looking for a life of convenience, one that takes no time, costs no money, and requires no effort.

—Marvin J. Ashton

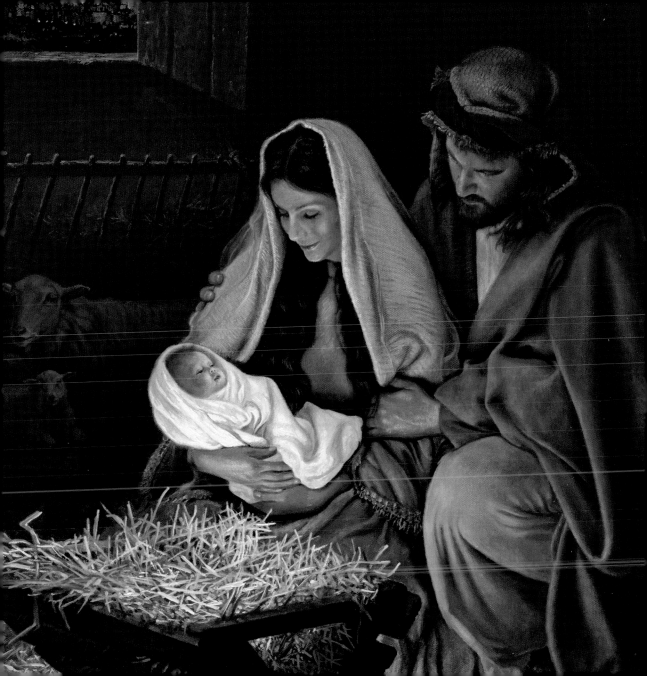

O Little Town of Bethlehem

How silently,
how silently,
The wondrous gift
is giv'n!
So God imparts to
human hearts
The blessings of
his heav'n.
No ear may hear
his coming;
But in this world
of sin,
Where meek souls will
receive him, still
The dear Christ
enters in.

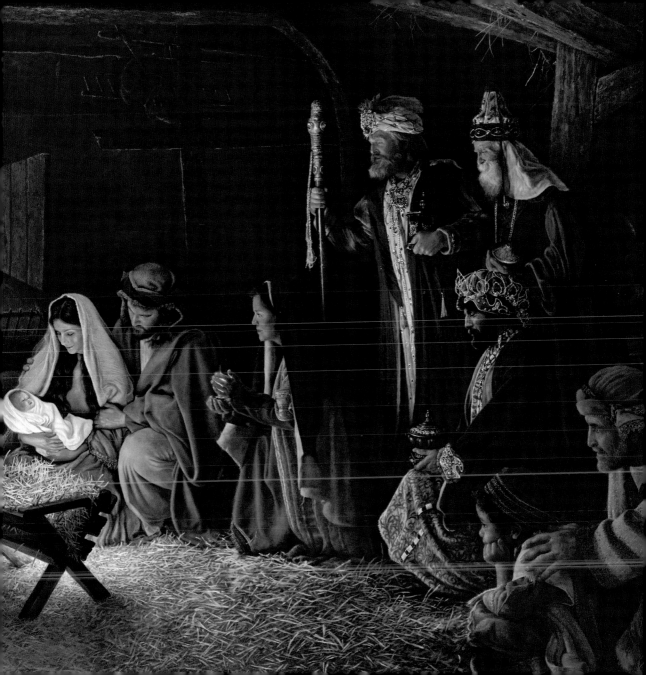

With Wondering Awe

With wond'ring awe the wise men saw
The star in heaven springing,
And with delight, in peaceful night,
They heard the angels singing. . . .
By light of star they traveled far
To seek the lowly manger,
A humble bed wherein was laid
The wondrous little Stranger. . . .

The star in the heavens was not the only star or the most important star. The star within the heart of the wise men was the important star. After all, if the star was in the sky for all to see then hundreds of thousands of people would have seen it and thousands of people could have wondered at its meaning, and hundreds could have followed it . . . with hope and patience. Only [the wise men] kneeled before the young child, Jesus. *They had a star within that enabled them to see the star without.* They saw it with the eyes of faith, and it brought them to Jesus.

–Chieko Okazaki

Where is he that is born King of the Jews? for we have seen his star in the east, and are come to worship him.

—MATTHEW 2:2

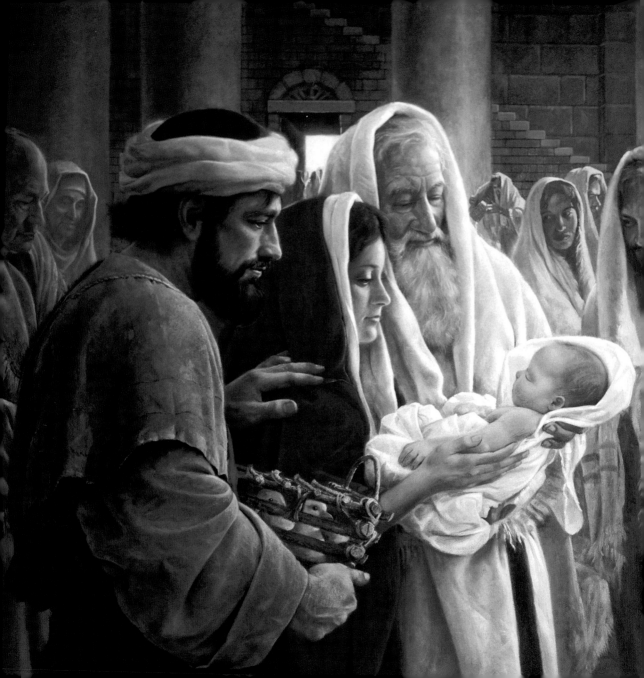

That Holy Thing

They all were looking for a king
To slay their foes and lift them high.
Thou cam'st a little baby thing
That made a woman cry.

—George MacDonald

And, behold, there was a man in Jerusalem, whose name was Simeon; and the same man was just and devout, waiting for the consolation of Israel: and the Holy Ghost was upon him.

And it was revealed unto him by the Holy Ghost, that he should not see death, before he had seen the Lord's Christ.

And he came by the Spirit into the temple: and when the parents brought in the child Jesus, to do for him after the custom of the law,

Then took he him up in his arms, and blessed God, and said,

Lord, now lettest thou thy servant depart in peace, according to thy word:

For mine eyes have seen thy salvation,

Which thou hast prepared before the face of all people;

A light to lighten the Gentiles, and the glory of thy people Israel.

—Luke 2:25–32

CHRISTMAS IS A LIGHT

Christmas is a light.

. . . a candle burning in a window.

. . . the gleam of a star on a tree.

. . . the light in the eyes of a child on

Christmas morning.

But Christmas is more than these.

Christmas is a light within.

There are men who object to Santa Claus, because he does not exist! Such men need spectacles to see that Santa Claus is a symbol; a symbol of the love and joy of Christmas and the Christmas spirit. In the land of my birth there was no Santa Claus, but a little goat was shoved into the room, carrying with it a basket of Christmas toys and gifts. The goat of itself counted for nothing; but the Christmas spirit, which it symbolized, counted for a tremendous lot.

—JOHN A. WIDTSOE

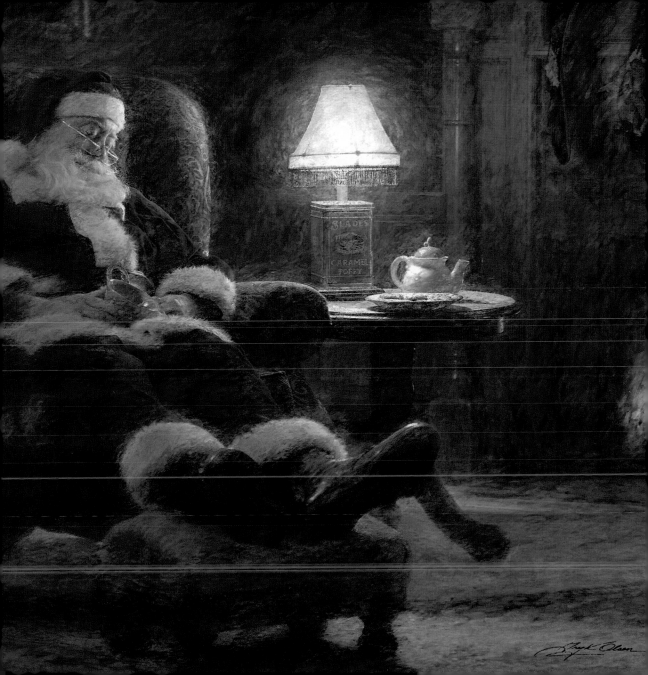

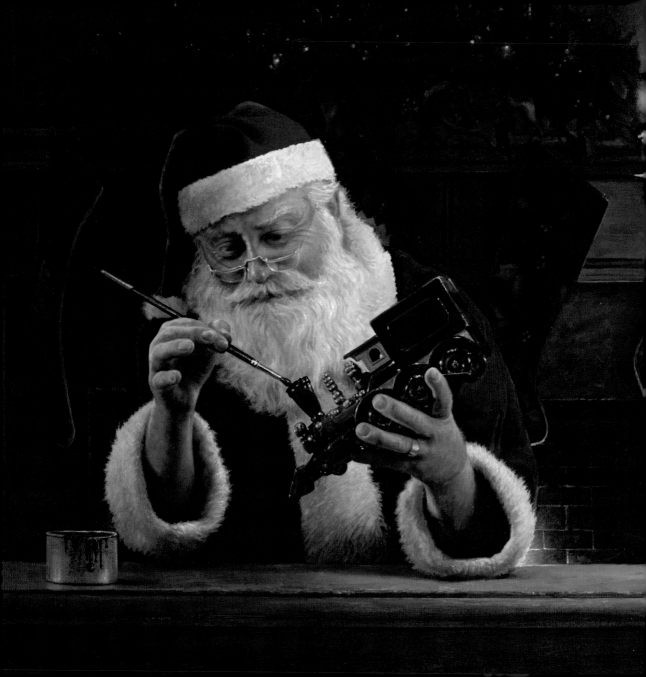

THE JOY OF GIVING

Somehow, not only for Christmas
But all the long year through
The joy that you give to others
Is the joy that comes back to you.
And the more you spend in blessing
The poor and lonely and sad,
The more of your heart's possessing
Returns to make you glad.

—JOHN GREENLEAF WHITTIER

It is a glorious thing to have old St. Nicholas in our hearts and in our homes today, whether he enters the latter through the open door or creeps down the chimney on Christmas Eve. To bring happiness to others without seeking personal honor or praise by publishing it is a most commendable virtue. . . .

Good old St. Nicholas has long since gone the way of all mortals, but the joy he experienced in doing kindly deeds is now shared by millions who are learning that true happiness comes only by making others happy—the practical application of the Savior's doctrine of losing one's life to gain it. In short, the Christmas spirit is the Christ spirit, that makes our hearts glow in brotherly love and friendship and prompts us to kind deeds of service.

—DAVID O. MCKAY

Every man
according as
he purposeth in
his heart, so let
him give; not
grudgingly, or
of necessity: for
God loveth a
cheerful giver.

—2 CORINTHIANS 9:7

LOVE DIVINE

Be ye therefore followers of God, as dear children;
And walk in love, as Christ also hath loved us, and hath
given himself for us an offering and a sacrifice to God.

—EPHESIANS 5:1-2

Perhaps one of the greatest blessings of this wonderful Christmas season we celebrate is that it increases our sensitivity to things spiritual, to things of God. It causes us to contemplate our relationship with our Father and the degree of devotion we have for God.

It prompts us to be more tolerant and giving, more conscious of others, more generous and genuine, more filled with hope and charity and love—all Christ-like attributes. No wonder the spirit of Christmas touches the hearts of people the world over. Because for at least a time, increased attention and devotion are turned toward our Lord and Savior, Jesus Christ.

This Christmas, as we reflect upon the wonderful memories of the past, let us resolve to give a most meaningful gift to the Lord. Let us give Him our lives, our sacrifices. Those who do so will discover that He truly can make a lot more out of their lives than they can.

—EZRA TAFT BENSON

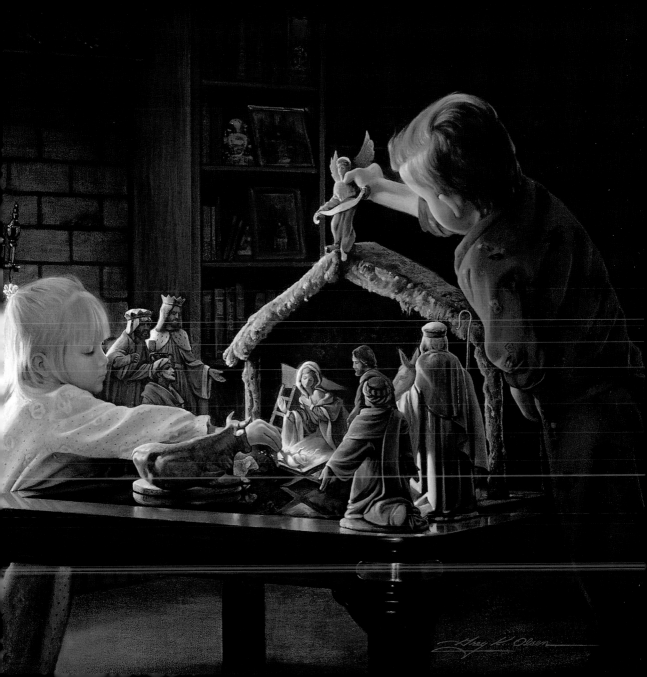

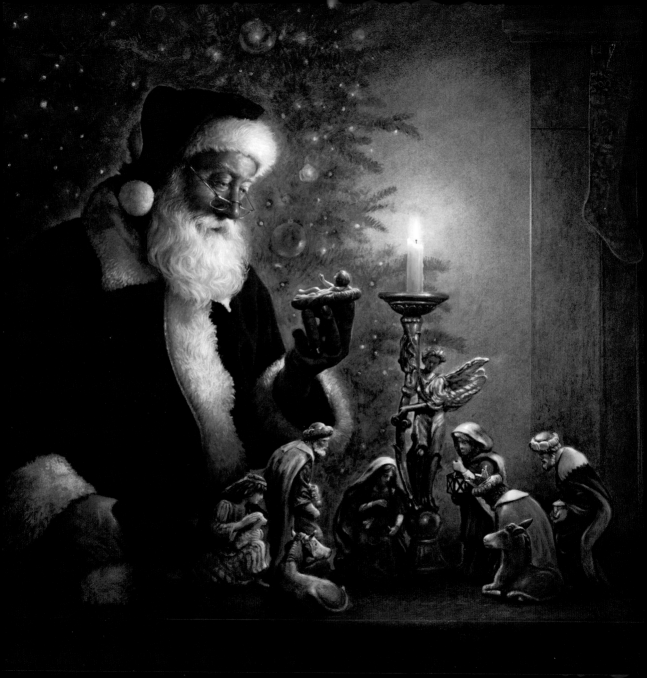

AWAY IN A MANGER

Away in a manger, no crib for his bed,
The little Lord Jesus laid down his sweet head . . .
I love thee, Lord Jesus; look down from the sky
And stay by my cradle till morning is nigh.
Be near me, Lord Jesus; I ask thee to stay
Close by me forever, and love me, I pray.
Bless all the dear children in thy tender care,
And fit us for heaven to live with thee there.

He before whom a few gifts were laid in that lowly manger has spread so many gifts before us, thereby providing an unending Christmas. In fact, from Him for whom there was no room in the inn there comes to the faithful so many blessings "that there shall not be room enough to receive [them]"! (Malachi 3:10).

—NEAL A. MAXWELL

Christmas means giving—and "the gift without the giver is bare." Giving of self, giving of substance, giving of heart and mind and strength in assisting those in need and in spreading the cause of His eternal truth— these are the very essence of the true spirit of Christmas.

—GORDON B. HINCKLEY

ABOUT THE ARTIST

*T*he art of Greg Olsen illuminates the soul and spirit of its subjects and uplifts the hearts and minds of its viewers. Olsen's diverse interests are deftly demonstrated in oil paintings that range from the realistic and historical to the whimsical. His luminous, delicate portraits capture not only his subject's likeness, but their spirit as well. Landscapes of scenes from America and the world over reflect the perfect beauty of the mind's eye.

Born in 1958, Olsen was raised in a farming community in rural Idaho. His parents, artists themselves, recognized and encouraged his early love of drawing. Later, the devoted tutelage of a high school teacher cemented his affinity and enhanced his technical ability. After studying illustration at Utah State University, he was hired as an in-house illustrator in Salt Lake City, working on anything from murals and dioramas to simple paste-up. Two years later, he followed a friend's advice and began painting full time. Sales from his first show only just covered the cost of refreshments and invitations, but yielded the first of many commissions that were to come.

Greg's philosophy on art is quite simple. "I appreciate the beauty of art and the way it makes me feel," he says. "I believe that art has the potential to heal our souls, inspire our hearts and awaken our minds. I hope these images will bring this experience to all who view them."

ENDNOTES

PAGE 3

James E. Faust, quoted in "News of the Church: First Presidency Christmas Devotional," *Ensign*, February 1999, 73.

Albert Choules, Jr., "Christmas Lessons," in *Christmas Treasures* (Salt Lake City: Deseret Book, 1994), 54–55.

PAGE 4

Faust, "A Christmas with No Presents," *Ensign*, December 2001, 4.

Howard W. Hunter, *Teachings of Howard W. Hunter*, Clyde J. Williams, ed. (Salt Lake City: Deseret Book, 1997), 270.

PAGE 7

Jay E. Jensen, "Likening Luke 2 to Our Lives," in *Christmas Treasures*, 110.

PAGE 8

Phillips Brooks, "O Holy Child," in *Christmas Classics: A Treasury for Latter-day Saints* (Salt Lake City: Deseret Book, 1995), 40.

Marvin J. Ashton, "The Child in the Manger," in *Christmas Treasures*, 135.

PAGE 10

Brooks, "O Little Town of Bethlehem," *Hymns of The Church of Jesus Christ of Latter-day Saints* (Salt Lake City: The Church of Jesus Christ of Latter-day Saints, 1985), no. 208.

PAGE 12

"With Wondering Awe," *Hymns*, no. 210.

Chieko N. Okazaki, *Stars: Reflections on Christmas by Chieko N. Okazaki* (Salt Lake City: Deseret Book, 2004), 4.

PAGE 15

George MacDonald, "That Holy Thing," *The Poetical Works of George MacDonald*, 2 vols. (London: Chatto & Windus, 1893), 2:323.

PAGE 16

"Christmas Is a Light," quoted in *I'll Be Home for Christmas: The Spirit of Christmas during World War II* (New York: Gramercy Press, 1999), 73.

John A. Widtsoe, "Temple Worship," *Utah Genealogical and Historical Magazine* 12 (April 1921): 62.

PAGE 19

John Greenleaf Whittier, "The Joy of Giving," in *Christmas Classics: A Treasury for Latter-day Saints* (Salt Lake City: Deseret Book, 1995), 96.

David O. McKay, *Gospel Ideals: Selections from the Discourses of David O. McKay* (Salt Lake City: Improvement Era, 1953), 550, 551.

PAGE 20

Ezra Taft Benson, *President Ezra Taft Benson Remembers the Joys of Christmas* (Salt Lake City: Deseret Book, 1988), 12–13.

PAGE 23

"Away in a Manger," *Hymns*, no. 206.

Neal A. Maxwell, *The Christmas Scene* (Salt Lake City: Bookcraft, 1994), 5.

Gordon B. Hinckley, "What Shall I Do Then with Jesus Which Is Called Christ?" in *Christmas Treasures*, 2.